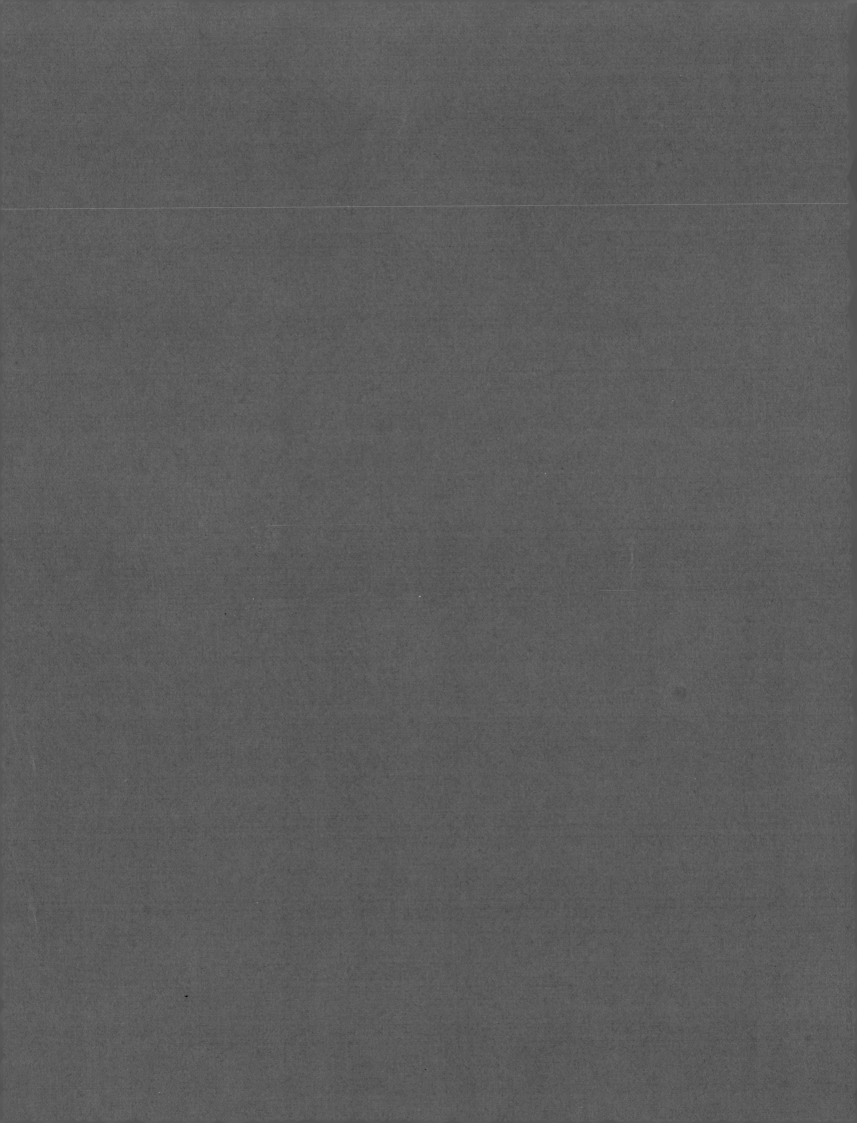

Richard Serra Torqued Spirals, Toruses and Spheres

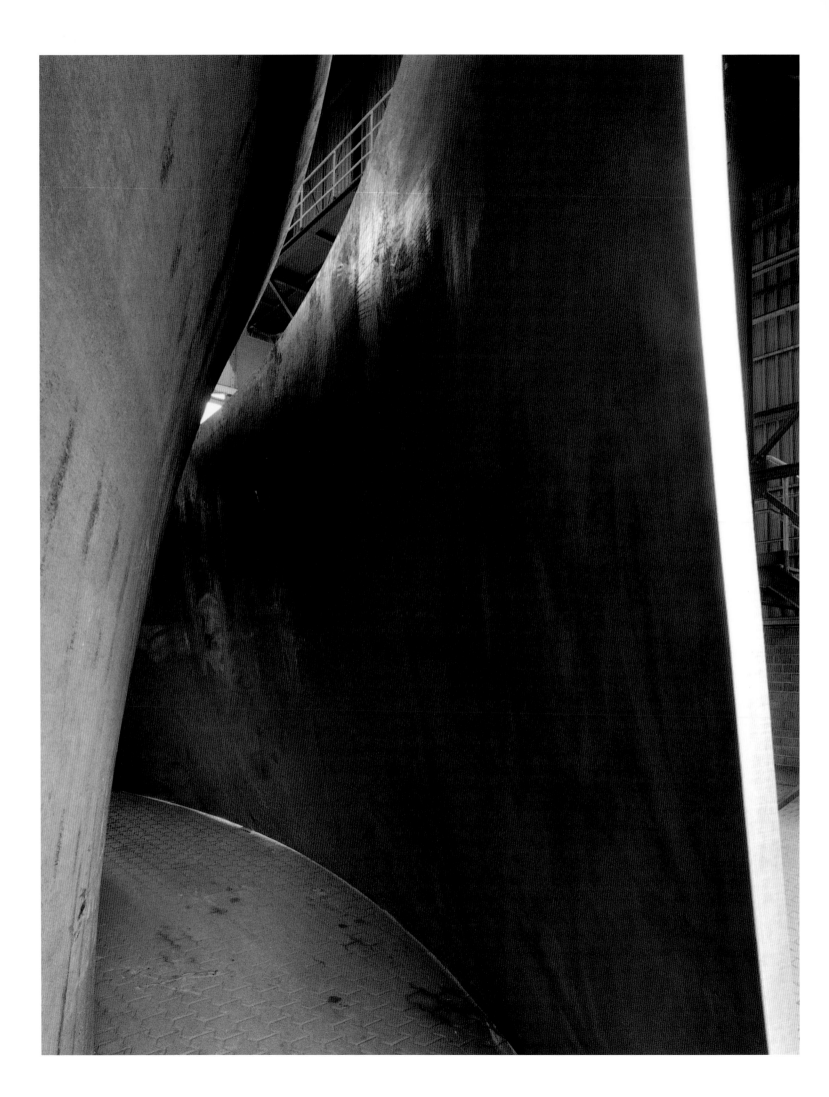

Essay by Hal Foster

Photographs by Dirk Reinartz

Richard Serra Torqued Spirals, Toruses
and Spheres

GAGOSIAN GALLERY | STEIDL

Contents

Torques and Toruses

Hal Foster

MANY MODERNISTS were committed to geometry—the squares of Malevich, the grids of Mondrian, the cubes, cylinders, and spirals of Tatlin, and so on—and many minimalists appeared to take this commitment to the limit— to reduce the object to its formal essence. For this reason Minimalism is often regarded as the epitome of modernist purity, yet this reading is mostly mistaken. Minimalists deployed pure forms, to be sure, but usually in order to show how they are transformed by our impure perception, complicated as it always is by embodiment, placement, and context.

In 1969 Richard Serra concentrated this demonstration in *One-Ton Prop*: here what one may have anticipated—a simple cube—diverged radically from what one witnessed—four rough lead slabs propped against one another like a fragile house of cards. Ever since Serra has put our perception of things in

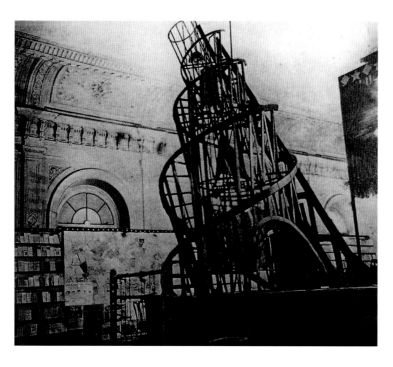

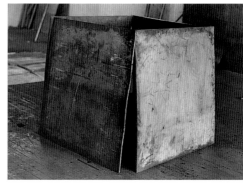

tension with our conception of them: he invites our bodies, informed by materials and structures, to do the thinking, "to think on our feet." Over the past 30-plus years he has wrung many variations on this theme, sometimes simple and direct, sometimes complex and elaborate. Not that his procedures have stayed the same: along with the "torqued ellipses" that precede them, the new "torqued spirals" in this show constitute a break in several respects, and the "torus" pieces are unprecedented in his art. However, as is often the case with sustained oeuvres, this break also repositions his past work, and so continues it in a new key.[1]

In this exhibition Serra recapitulates important aspects of his sculptural language, and develops them further. Long ago this language began to focus on the body in movement through a space carved out by the sculpture. Its basic principle was phenomenological: the work exists in primary relation to a situated body, not as its representation but as its activation, in all its senses, all its gaugings of weight and measure, size and scale. By 1973, soon after his landscape pieces *Shift* (1970–72) and *Spin Out* (1971–72), Serra could describe "the sculptural experience "in terms of a "topology of [a] place" demarcated "through

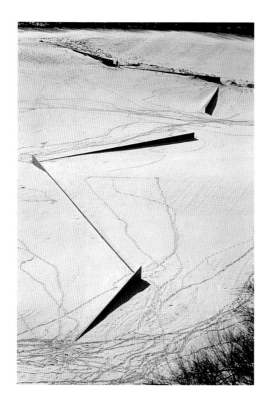

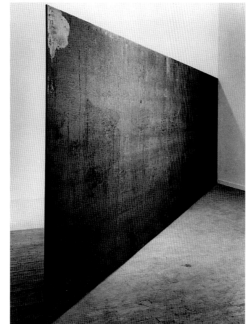

locomotion," a "dialectic of walking and looking into the landscape."[2] Here he pushed the phenomenological basis of his art toward a "parallactic" redefinition, such that his sculpture would frame and reframe both viewer and site in tandem. It is this model that has guided Serra in his urban as well as his natural settings ever since.

In this show *Elevational Wedge* harks back to his interventions, early and late, both in galleries (e.g., *Strike*, 1969–71) and in landscapes (e.g., *On the Level*, 1991). It is keyed to a detail of the given architecture of the Gagosian Gallery, an existing ramp in its south gallery. Over a 10 foot 10 inch span

this steel wedge, from 5 inches deep to zero, levels this incline along a 21 foot 8 inches length. With the simplest means this piece articulates the gallery—it is suddenly drawn into the work—and pressures it at the same time—literally so, as the space above the steel seems compressed by it. The wedge also subtly recalls the prior use of this space in a different kind of economy—an industrial, workaday economy, not a commercial, sumptuary one.

With the heavyweight piece here, titled *Ali-Frazier*, Serra again recovers an established type in his work, the solid block, which was first developed as a counterpoint

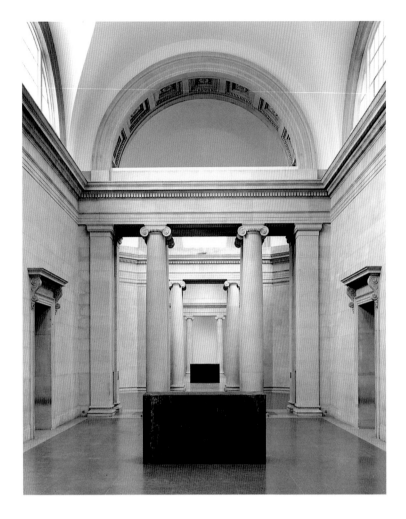

Weight and Measure, 1992

Forged weatherproof steel
Two blocks:
5' x 9'1½" x 3'5"
5'8" x 9'1½" x 3'5"
Installation in the
Duveen Sculpture Galleries
of the Tate Gallery,
London, England
Photo: Stefan Erfurt,
Wuppertal

haptic eye that, again, must remember and judge both weight and measure. This sort of perceptual skill, largely lost today, was once fundamental to daily economic life, and, as the art historian Michael Baxandall has demonstrated, it was also crucial to much Renaissance art making and viewing.[3] Here again Serra recalls a kind of past to us, a more distant one than the past of the industrial ramp in the gallery, but one that may remain vestigial in our bodily memory nonetheless.

If the wedge and the blocks resume prior types in his work, the two pieces here that consist of spheroid sections and toruses, all 12 feet high, announce a new vocabulary; but it is a vocabulary that again develops established terms like the blocks and the arcs. To begin to understand these forms, picture a column or (better) a doughnut: its outside edge will describe a spheroid section, while its inside edge will describe what is called a torus, and each will have the same radius. With his toruses, however, Serra bends the inner edge back around, so that, when put together with the spheroid section, the two lock like the nonsymmetrical shells of a collapsed clam, or the warped sides of a strange wing or ship, as they do in *Union of the Torus and the*

to the spatial manipulations of his arcs (single, double, and treble) of the 1980s and '90s. Like the rounds that emerged with them, these blocks absorb space through sheer mass, like so many black holes, rather than define space through steel planes, as in the arcs. Yet *Ali-Frazier* tests our sense not only of mass but of size as well; the piece is equally concerned with "weight and measure," as the title of an earlier pair of blocks phrases it. Set in two separated rooms that are virtually identical, the two blocks are not identical, and we are left first to recall the differences and then to calibrate them by eye—by a sort of tactile or

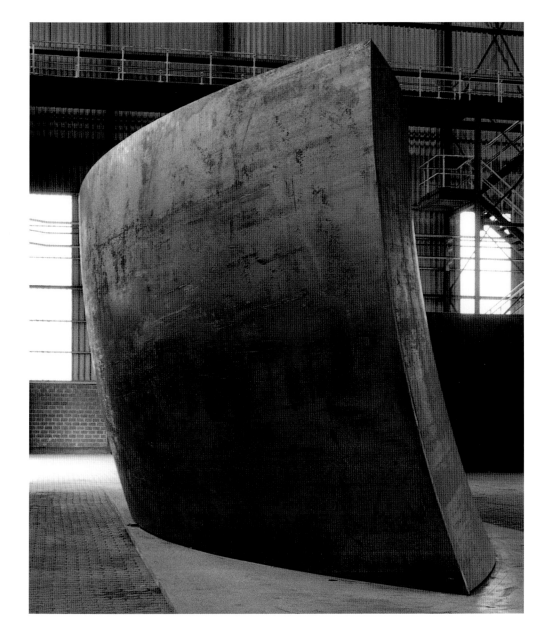

Union of the Torus
and the Sphere, 2001

One spherical section;
One torus section
Weatherproof steel
Spherical section: 11'10" x 37'9"
Torus section: 11'10" x 37'6"
Overall: 11'10" x 37'9" x 10'5"
Plate thickness: 2"

Sphere. At first this closed volume may look familiar, like some sort of tomb, perhaps the most primordial of sculptural forms, or like a Minimalist object à la Donald Judd, a more proximate allusion. But the structure of *Union of the Torus and the Sphere* appears more fantastic than either of these precedents; and although this attribute might align it in turn with Surrealist sculpture, that association does not seem quite right either. The result is a new kind of object for Serra—he has never made a sculpture that cannot be entered bodily or visually somehow—and as such it invites further exploration.

Serra begins this exploration here with *Betwixt the Torus and the Sphere*, which consists of three toruses and three spheroid sections put together in a way that produces five passageways over a length of some 37 ½

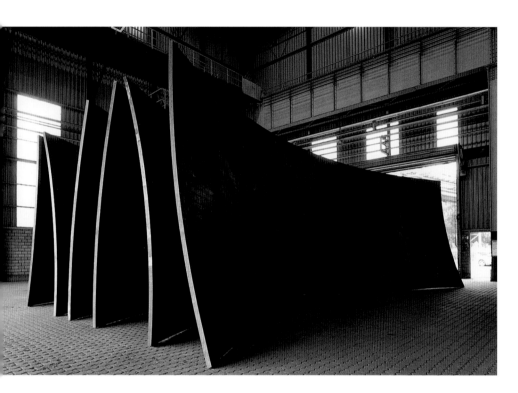

focus on the torqued spirals, a series introduced at the Venice Biennale and seen in New York for the first time now. The two spirals on view are *Bellamy* (the larger one, nearly 46 feet on its long axis) and *Sylvester*, which Serra titled in honor of two recently deceased friends, the American dealer-curator Dick Bellamy and the English critic-curator David Sylvester.

"In all my work," Serra wrote in an important text of 1985, "the construction process is revealed. Material, formal, contextual decisions are self-evident. The fact that the technological process is revealed depersonalizes and demythologizes the idealization of the sculptor's craft." This statement of purpose reflects the renewed interest in Russian Constructivism among young artists in the 1960s like Carl Andre, Dan Flavin, and Serra. Its aesthetic (which is also a politics and an ethics) can be summed up in the principle of *structural transparency*—that is, that a work must demonstrate its own construction. Far more rigorous than any pledge of formal purity, this is a modernist principle to which Serra has remained loyal. However, to see how a piece is *constructed* is not necessarily to know how it is *configured*; and, just as Serra exploited the

Betwixt the Torus
and the Sphere, 2001

Three spherical sections;
Three torus sections
Weatherproof steel
Each approx.: 11'10" x 37'6"
Overall: 11'10" x 37'6" x 26'7"
Plate thickness: 2"

feet, with openings that range from 6 feet to 30 inches wide. One intuits that the modules of *Betwixt* are the same as in *Union of the Torus and the Sphere*, and this keys our reading of both. In a sense each work is the obverse of the other: while *Union of the Torus and the Sphere* foregrounds the surface qualities of the torus-sphere units (for we cannot penetrate it, it is all exterior), *Betwixt* elaborates its spatial possibilities (for it is all corridor). We must await the further articulation of these forms and spaces to see how this particular idiom will develop.

In the space left to me here I want to

felt tension between perception and conception in his early work, so he often plays on the felt discrepancy between construction and configuration in his later work. This is best understood in architectural terms: the "elevation" of a recent Serra sculpture (i.e., the diagrammatic view *en face*) rarely reveals the "plan" of the work (i.e., the diagrammatic view from above), and vice versa; neither conveys the identity of the other, let alone of the sculpture as a whole.[4] This discrepancy implies a critique of architectural protocols (a persistent aspect of his work); more intrinsically, it prevents any reduction of sculptural physicality to pictorial image. (Serra never proceeds from drawing to sculpture; there is no image before the model in his working method.) In a sense this prevention "blinds" us optically—we cannot project the work beforehand—in a way that allows us to "see" the work haptically—in the flesh, as it were.

The upshot is that structural transparency is complicated and geometric form distorted. If these two terms can be taken to stand for a kind of Minimalist "classicism", then with his multiple arcs, torqued ellipses, and torqued spirals Serra has produced, apparently on his own, a sort of "baroque" counterpart. The word means "misshapen

pearl," yet for the philosopher Gilles Deleuze "the fold" is the more apt term for the signal forms of the historical Baroque, from the art of Tintoretto and the architecture of Borromini to the philosophy of Leibniz: "The Baroque refers not to an essence but rather to an operative function, to a trait. It endlessly produces folds."[5]

One prime effect of the Baroque "fold" is to detach interior from exterior: "Baroque architecture can be defined by this severing of…the autonomy of the interior from the independence of the exterior, but in such conditions that each of the two terms thrusts the other forward."[6] Deleuze relates this effect—which is precisely that of the torqued ellipses and spirals—to the painterly definitions of Heinrich Wölfflin (on whose definition of the Baroque so much art history depends) as well as the (meta)physical reflections of Leibniz: "As Wölfflin has shown, the Baroque world [of painting] is organized along two vectors, a deepening toward the bottom, and a thrust toward the upper regions. [In his meta/physics] Leibniz [also] makes coexist, first, the tendency of a system to find its lowest possible equilibrium where the sum of masses can descend no further and, second, the tendency to elevate, the highest aspiration of

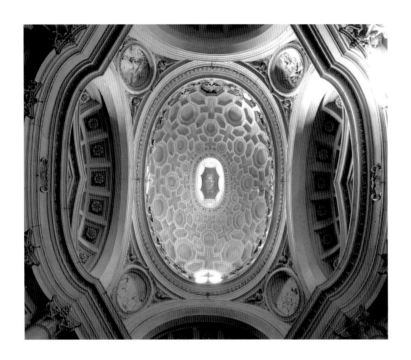

cylinder." For me walking in from the side aisle was more interesting than standing in the central space. Then it occurred to me that I could possibly take what I perceived from the side aisle, and torque the space.[8]

In effect, Serra saw that he might twist in elevation such volumes as oval cylinders, ellipses, and now spirals. First he tested the intuition with a model made up of two wood ellipses held parallel but askew to each other by a dowel. He made a template from this model, and a lead sheet was cut and rolled from it. Serra then applied the computer program CATIA to calculate the necessary bending of the projected ellipses at full scale—a bending that only a few steel mills in the world could execute. This is how the torqued ellipses, first singles, then doubles, were generated, and the torqued spirals followed. In his own words the effects are Baroque:

a system in weightlessness, where souls are destined to become reasonable."[7] Such a "system"—of counter-posed "vectors" and masses coexistent with weightlessness—is also very pertinent to the torqued ellipses and spirals.

If my Baroque association seems forced, Serra has made it as well. In part the torqued ellipses were inspired by a visit to Borromini's San Carlo Church in Rome.

The space [of the central dome] rises straight up and doesn't change in its regular oval form from top to bottom. It is kind of an "oval

Their outside is totally different from their inside…
You don't know the form even if you walk around it several times. When you walk inside the

piece, you become caught up in the movement of the surface and your movement in relation to its movement...

You become implicated in the tremendous centrifugal force in the pieces. In relation to the space of the entire exhibition there is a decentering...[9]

Again, this Baroque disconnection between elevation and plan, inside and outside, was already pronounced in the multiple arcs, but they still carved out a principal trajectory that your gaze tracked beforehand. This is not true of the torqued ellipses, and even less so of the torqued spirals; one cannot really project ahead at all. The walls tilt in and out, left and right, sometimes together, often not; as a result they pinch, then release, and then pinch again, in ways that cannot be calculated precisely because they are torqued, because the radii of the curves do not hold steady. There is no way to gauge the structure or the space ahead; and the same goes for the skin: "Because the surface is continuously inclined, you don't sense the distance to any single part of the surface. It's very difficult to know exactly what is going on with the movement of the

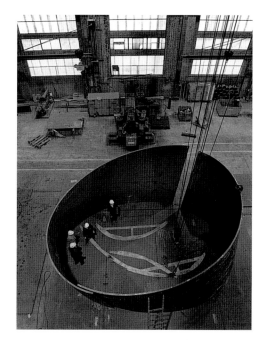

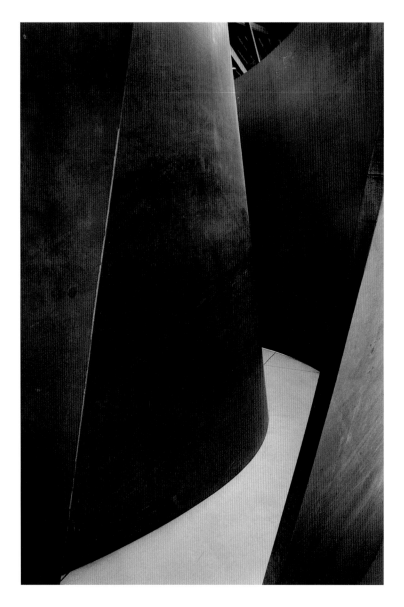

as the walls open up again, this weight is somehow eased; it seems to be funneled up and away from you. Suddenly both your body and the structure feel almost weightless—once again even more so with the spirals, as they seem to spin more smoothly, more rapidly, as you walk through. It is as if your body becomes its own roller coaster, one tracked not up and down but round and round.

Once more the effect can be described as Baroque, for you may feel overwhelmed by the spaces of the torqued ellipses and spirals. At the same time *you* may seem to overwhelm *them*—as if these spaces were somehow projections of your own body, of its fantasies. In this way Serra has opened up a psychological dimension new in his sculpture, an almost Surrealist sense of spatiality. The Surrealists were fascinated by archaic structures like the labyrinth and the omphalos, and there are hints of these ancient forms here as well. They also imagined an intrauterine architecture, and there is a trace of this primal fantasy too. But one never feels completely lost in the way that the Surrealists sought to be in their fantasmatic spaces: the torques are not mazes—one knows one is headed either toward or away from the openings—and the

surface."[10] One feels continuously dislocated—even more so with the spirals, which, unlike the ellipses, do not have a common center and are not sensed as two discrete forms. Again, even more so with the spirals, one feels that each new step produces a new space, a new sculpture, even a new body. Sometimes, as the walls pinch in, you feel the weight press down—not only of your body but also of the five plates, each 20 tons, that make up each spiral. But then,

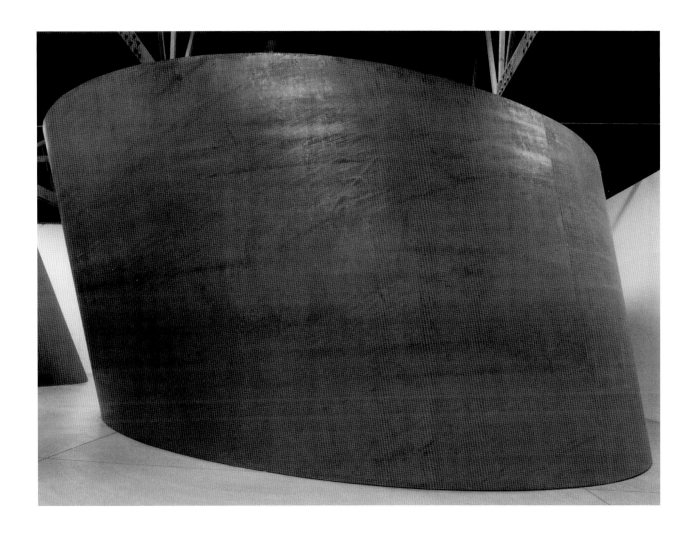

Double Torqued Ellipse, 1997

Weatherproof steel
Outer ellipse: 13'1" x 33'6" x 27'1"
Inner ellipse: 13'1" x 25'11" x 20'11"
Plate thickness: 2"
Collection: Dia Center for the Arts,
New York (gift of Leonard and
Louise Riggio)

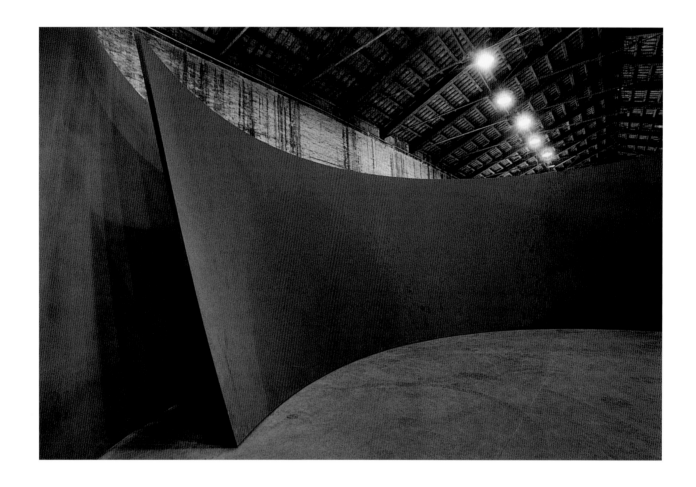

Left/Right, 2001

Torqued spiral
Weatherproof steel
Overall: 12'6" x 44' x 40'
Plate thickness: 2"
Private Collection

centers refuse the oracular aura of the omphalos. Rather, the new sense of Surrealist spatiality in the ellipses and spirals works to complement—to complicate—the old commitment to Constructivist tectonics. At this point Serra has elaborated Constructivist tectonics to the point where it converges with Surrealist spatiality, its historical other; in so doing, he suggests, dialectically, a new language of building, one fixated

neither on rigid structure nor on wacky biomorphism.[11]

Even as the torqued ellipses and spirals evoke archaic, psychic spaces like the labyrinth and the omphalos, they also conjure up futuristic, technological spaces like the virtual architectures of computer design.[12] In different ways both kind of space—archaic and futuristic—are fantasmatic, simulacral, and often ideological,

and Serra constrains both through three insistences that run deep in his work: insistences on the embodiment of his viewers, on the rationality of his constructions, and on the industrialism of his materials.

Infatuated with digital design, some contemporary architecture work to deliver us, disembodied, into virtual space. Often this architecture is also Baroque in its effects, but in the negative sense of design that overwhelms the subject with consumerist spectacle, just as the historical Baroque sought to awe its subjects with theatrical displays of the power of God in the church, or of the prince in the palace. In this "warped space," as architectural theorist Anthony Vidler calls it, there is often a collapsing of physical coordinates—a collapsing that Serra also evokes but only in order to check, again in the interests of embodiment, placement, and context rather than the digital "transcendence" of these qualities.[13] As a result he stays clear of the two great pitfalls of neo-Baroque architecture today: its tendency to indulge in arbitrary forms, and its tendency to efface the subject.

Both points require quick clarification. As for the first: today, with computer-assisted design and manufacture, it seems as if any form can be conjured and built; often there

is little structural constraint in digital architecture. As a result there is a relative disinterest in tectonic thinking and a relative arbitrariness in formal invention. However much Serra has complicated structural transparency, he has always insisted on structural necessity, and that apparent conservatism now takes on the value of critical resistance.[14]

As for the second point: the computer screen does not place its viewer punctually, at least not in the manner of past forms of representation like perspective, or other media like painting, film or television. In digital design there is also an apparent auto-generation of form that is almost oblivious to its operator. As a result there seems to be no set position for the subject; he, she, it is unfixed.[15] Even as the torqued pieces are not as phenomenological or as parallactic as many of earlier works by Serra—again, they too intimate a kind of velocity, even a sort of virtuality, that is disruptive—they hardly disembody, much less displace, the subject. On the contrary.

Much contemporary art—I have in mind computer-controlled film projections and video installations, one of the artistic Esperantos of the present—also seems pledged, consciously or not, to project us

into virtuality, or at least to ease us there, to reconcile us to such a furture-become-present. Serra is again more critical because he is more historical. In his art and its contexts there is a layering of past modes of production, a palimpsest of historical spatialities and subjectivities. As is well known, steel mills were crucial to his formation, and his father worked as pipe fitter in a Bay Area shipyard (nautical associations are not far from the new pieces). Through material and method Serra has long inscribed a kind of industrial mnemonic in his sculpture, one that is made especially articulate in particular contexts like the Arsenale in Venice, a great shipyard of post-Renaissance Europe and an early site of assembly production. This rooting in the industrial order may be dismissed as a nostalgia for modernist tectonics and heroic objects. But in the torqued ellipses and spirals it serves a different function: as a grounding from which new modes of production, new spatialities and subjectivities, can be probed, and where the complexity of social experience can be momentarily retained, not futuristically flattened.

1 For more on this logic see my "The Un/Making of Sculpture," in Russell Ferguson, ed., *Richard Serra Sculpture 1985–1998* (Los Angeles: Museum of Contemporary Art, 1998), and the other texts collected in Hal Foster, ed., *Richard Serra* (Cambridge: MIT Press, 2000).

2 Richard Serra, *Writing Interviews* (Chicago: University of Chicago Press, 1994), 15.

3 See Michael Baxandall, *Painting and Experience in Fifteeneth-Century Italy* (Oxford: Oxford University Press, 1972).

4 See Yve-Alain Bois, "A Picturesque Stroll around *Clara-Clara*," in Foster, ed., *Richard Serra*.

5 Gilles Deleuze, *The Fold: Leibniz and the Baroque*, trans. Tom Conley (Minneapolis: University of Minnesota Press, 1992), 3.

6 Ibid., 28.

7 Ibid., 29.

8 Michael Govan and Lynne Cook, "Interview with Richard Serra," in *Torqued Ellipses* (New York: Dia Center for the Arts, 1997), 22.

9 Ibid., 18, 17, 22.

10 Ibid., 16.

11 This Constructivist/Surrealist dialectic is not an historical artifact, for it continues in the opposition between "deconstructivist" and "blob" architectures today.

12 This archaic/futuristic duality is also in play in two obvious comparisons with other spirals: Tatlin's *Monument to the Third International* and Smithson's *Spiral Jetty*.

13 See Anthony Vidler, *Warped Space* (Cambridge: MIT Press, 2001). Christine Buci-Glucksmann first related postmodernism to the Baroque through a shared "folie du voir" in *La raison baroque* (Paris: Editions Galilée, 1984).

14 "The Ellipse project…represented the total opposite of the construction of the Guggenheim Museum in Bilbao, which is built like a traditional nineteenth-century sculpture, where the skin is wrapped around the inside and outside of an armature. The steel Ellipses establish the entire form, the inside and the outside, with one material" ("Interview with Richard Serra," 27).

15 Vidler explains further: "Ostensibly, there is little to distinguish Alberti's [perspectival] window from a computer screen, as there is to differentiate an 18th-century axonometric by Gaspard Monge from a wire frame dinosaur generated by Industrial Light and Magic. What has changed, however, is the technique of simulation, and, even more importantly, the place or position of the subject or traditional 'viewer' of the representation. Between contemporary virtual space and modernist space there lies an aporia formed by the autogenerative nature of the computer program and its real blindness to the viewer's presence. In this sense, the screen is not a picture, and certainly not a surrogate window, but rather an ambiguous and unfixed location for a subject" ("Warped Space: Architecture and Anxiety in Digital Culture," Power Institute Lecture, University of Sydney, 2000).

Bellamy

Torqued spiral, 2001

Weatherproof steel
Overall: 13'2" x 44'3" x 32'10"
Plate thickness: 2"

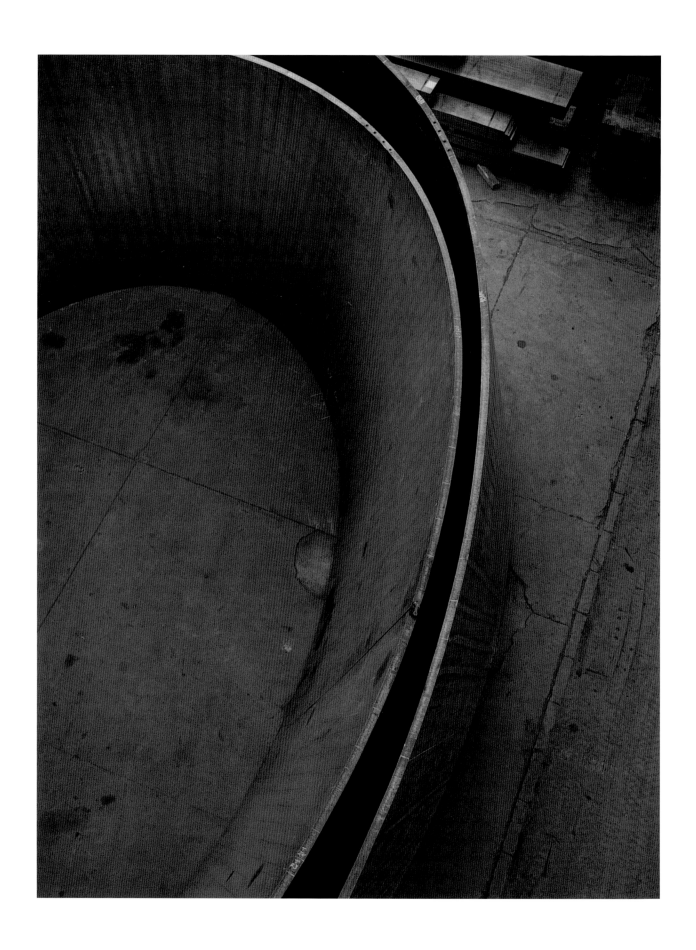

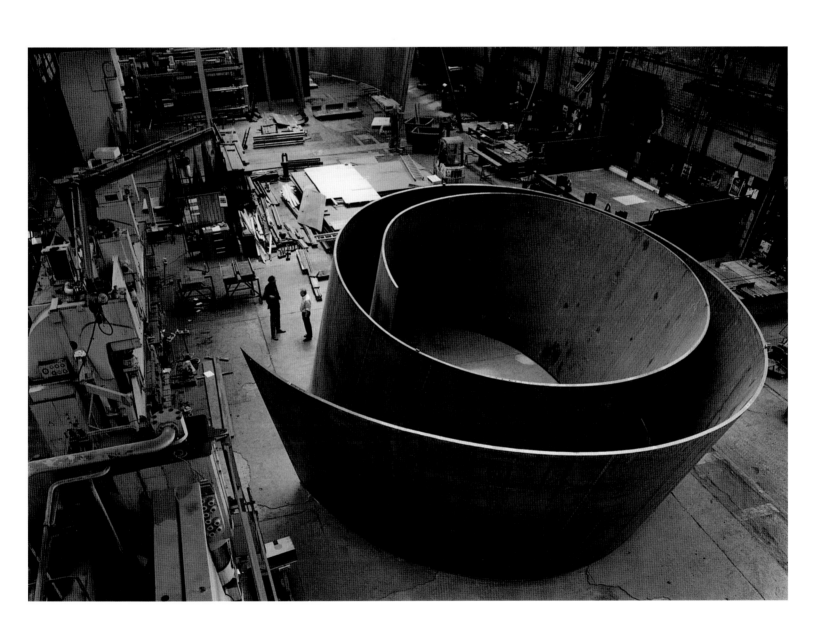

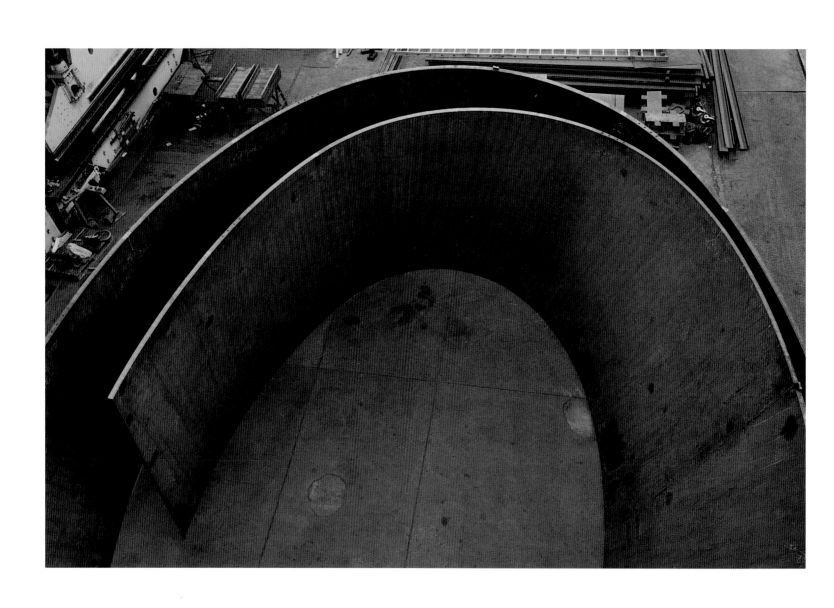

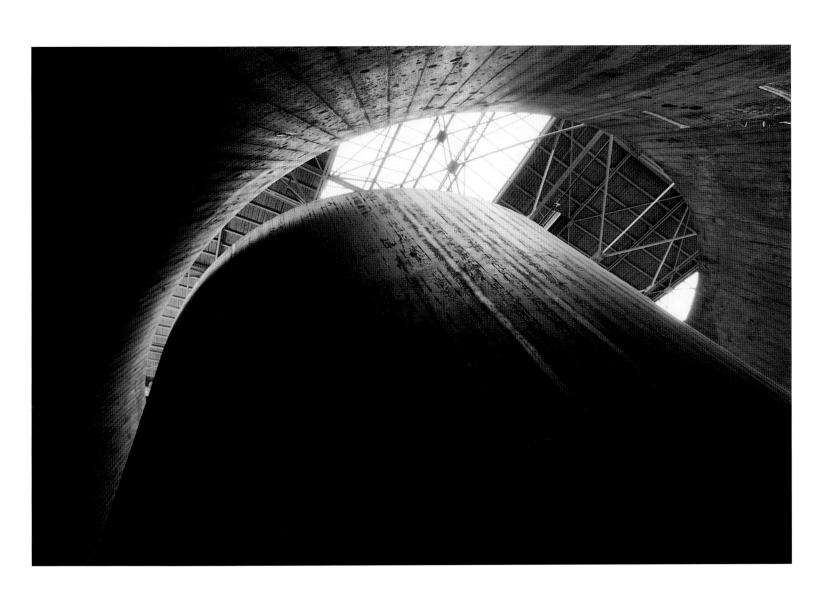

Sylvester

Torqued spiral, 2001

Weatherproof steel
Overall: 13'7" x 41' x 31'8"
Plate thickness: 2"

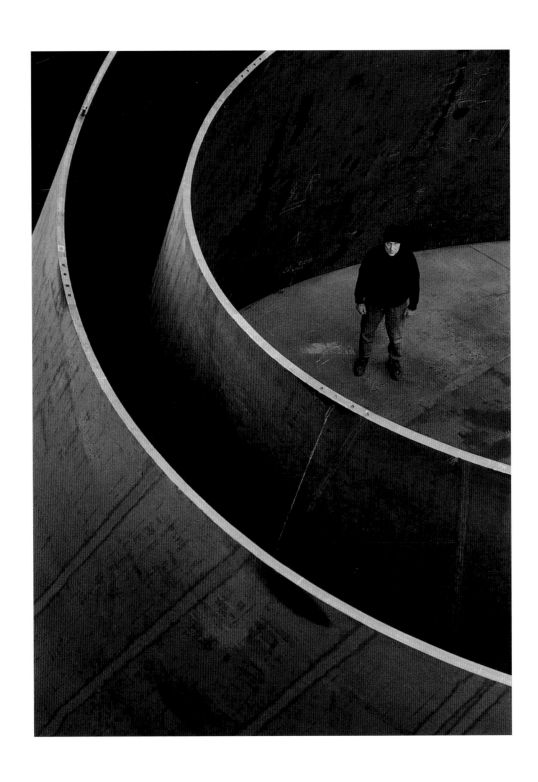

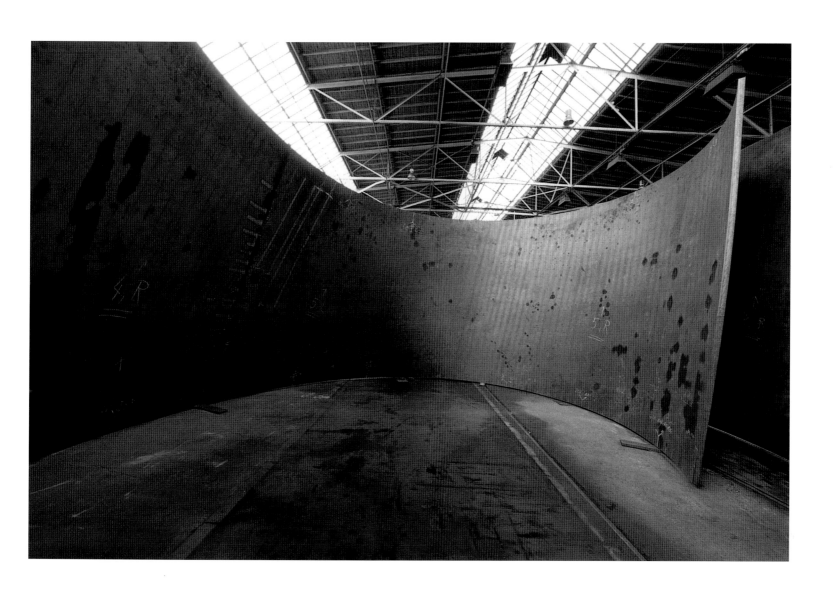

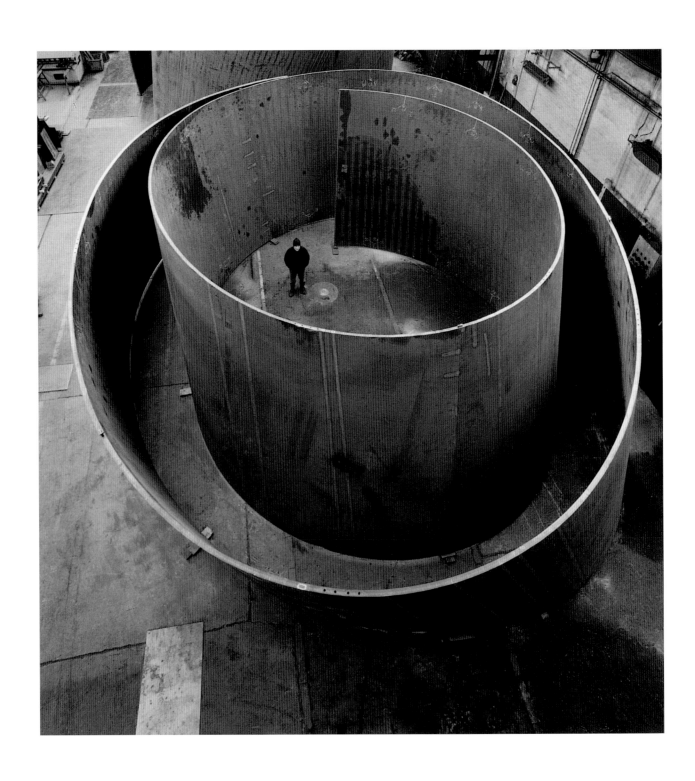

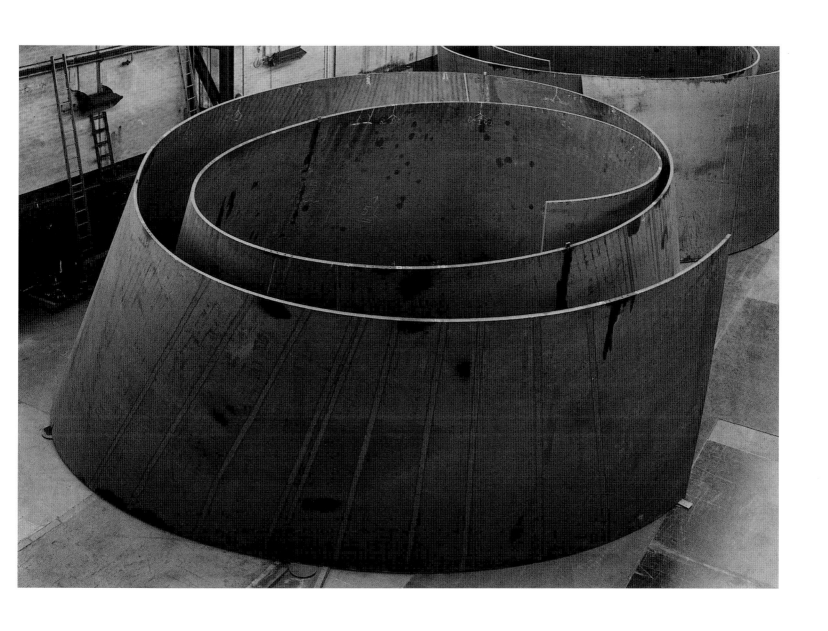

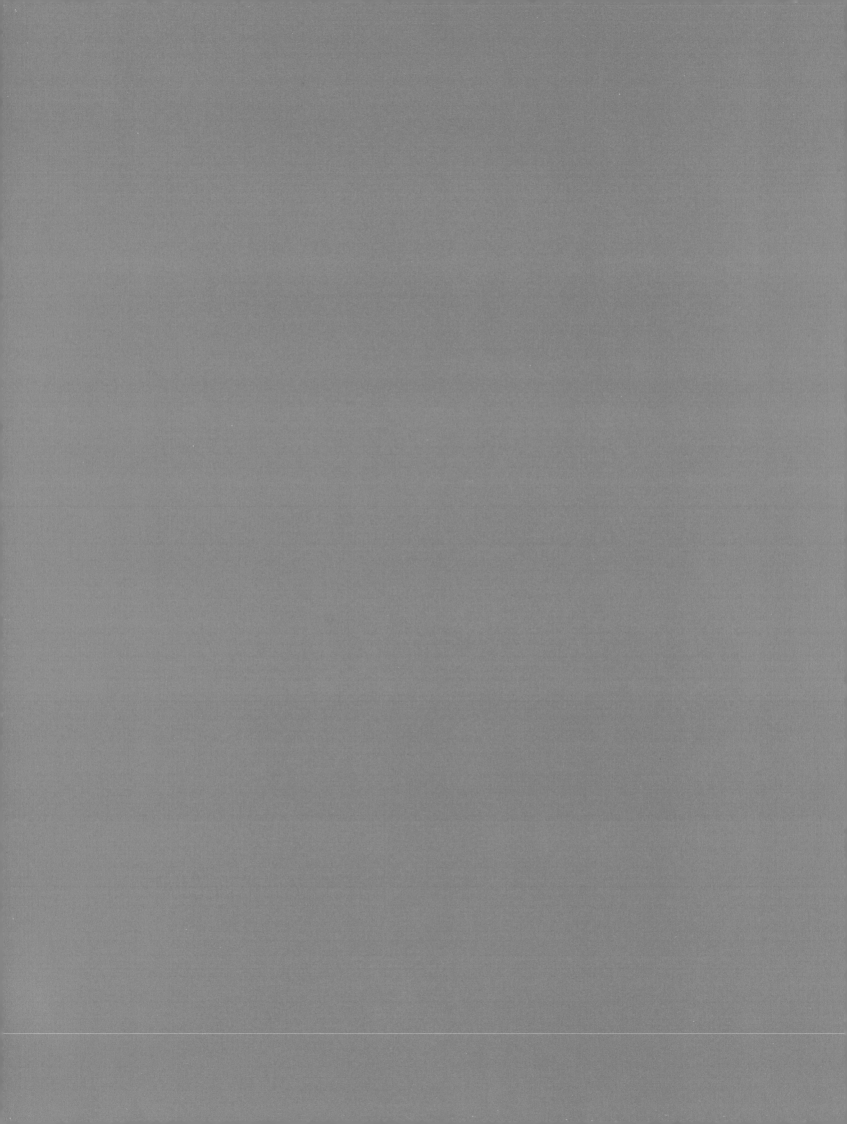

Joe

Torqued spiral, 2000

Weatherproof steel

Overall: 13'6" x 44'10" x 37'6"

Plate thickness: 2"

Collection: Pulitzer Foundation
for the Arts, St. Louis

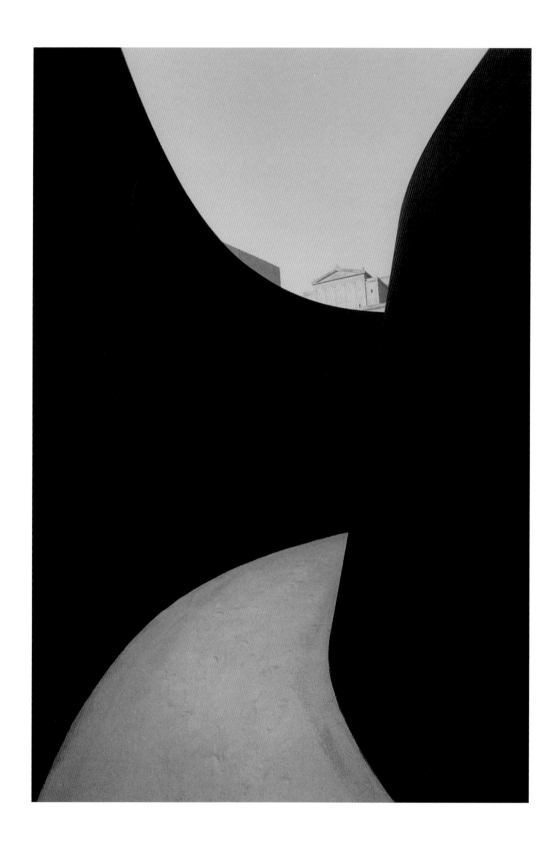

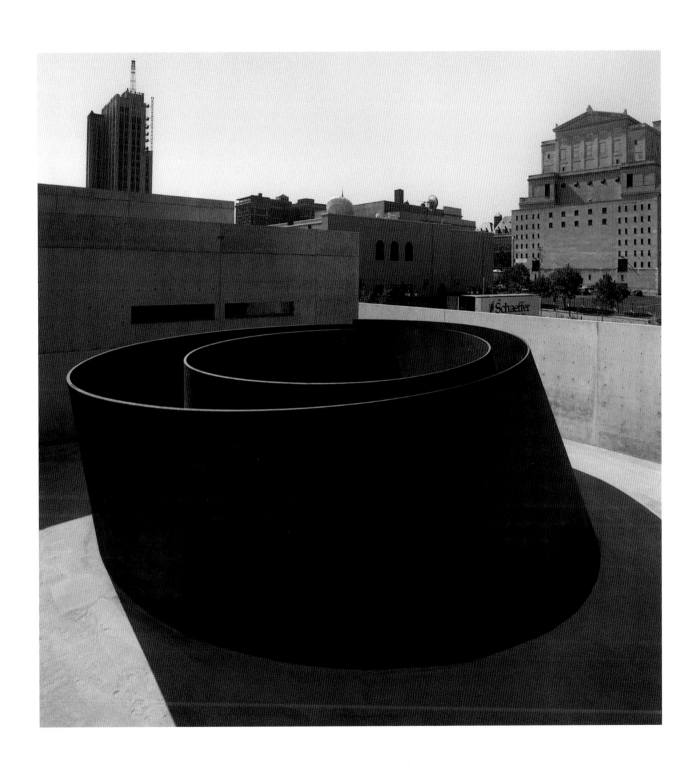

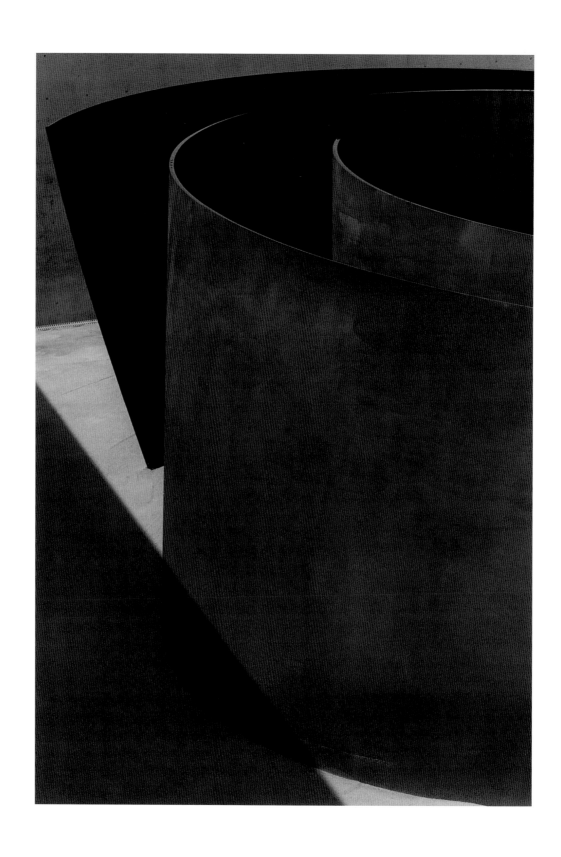

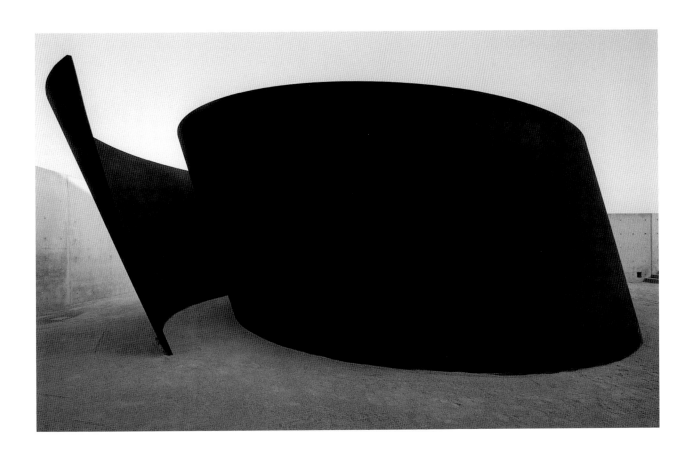

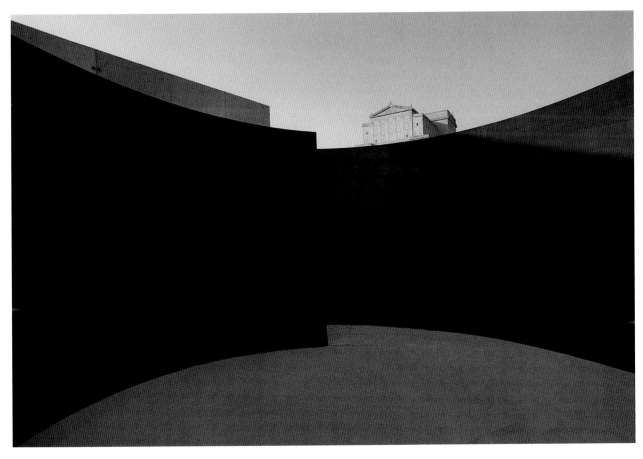

Four

Torqued spiral, 2001

Weatherproof steel
Overall: 13'7" x 40'4" x 36'
Plate thickness: 2"
Private collection

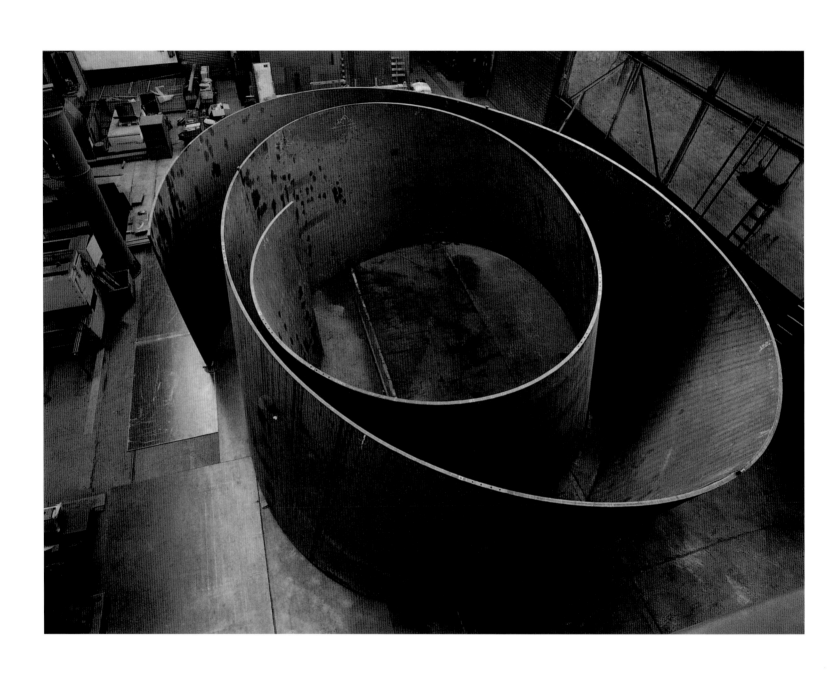

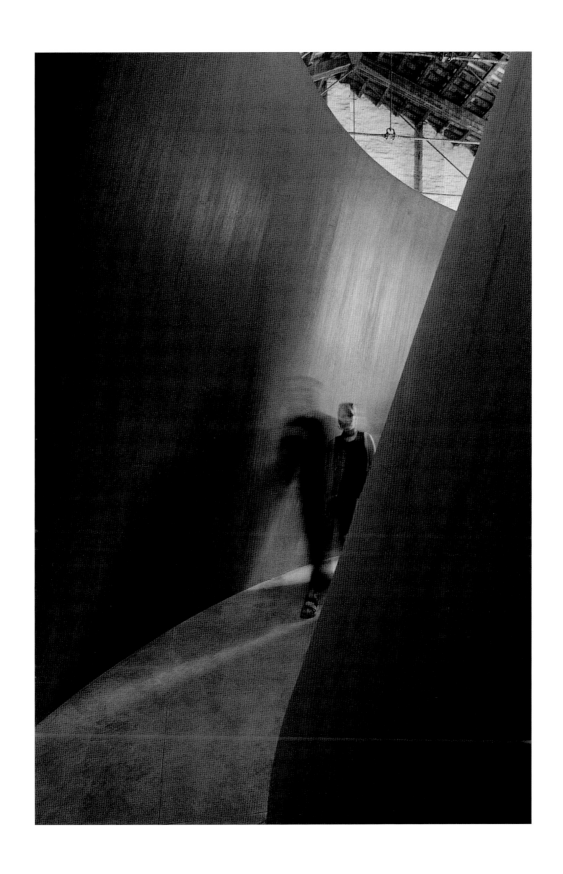

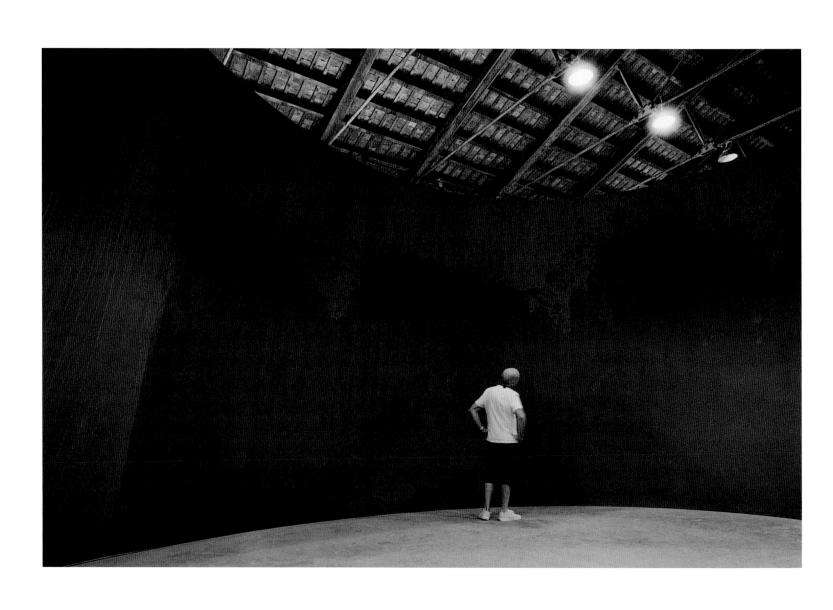

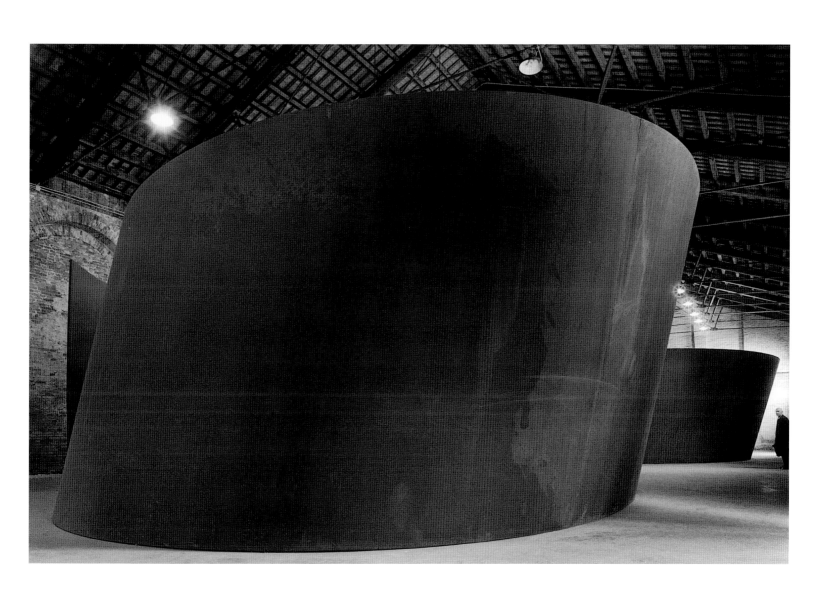

Left / Right

Torqued spiral, 2001

Weatherproof steel
Overall: 12'6" x 44' x 40'
Plate thickness: 2"
Private collection

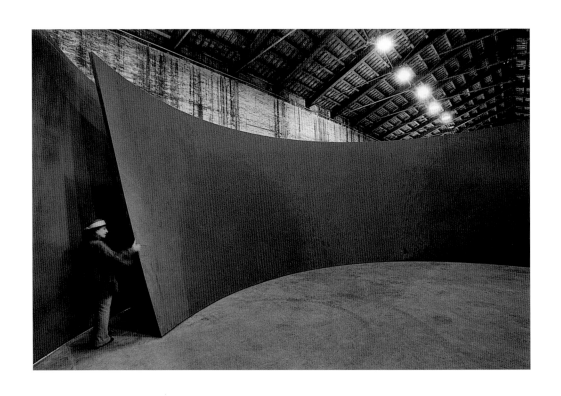

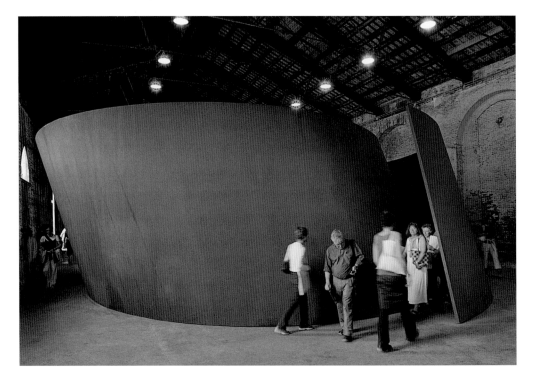

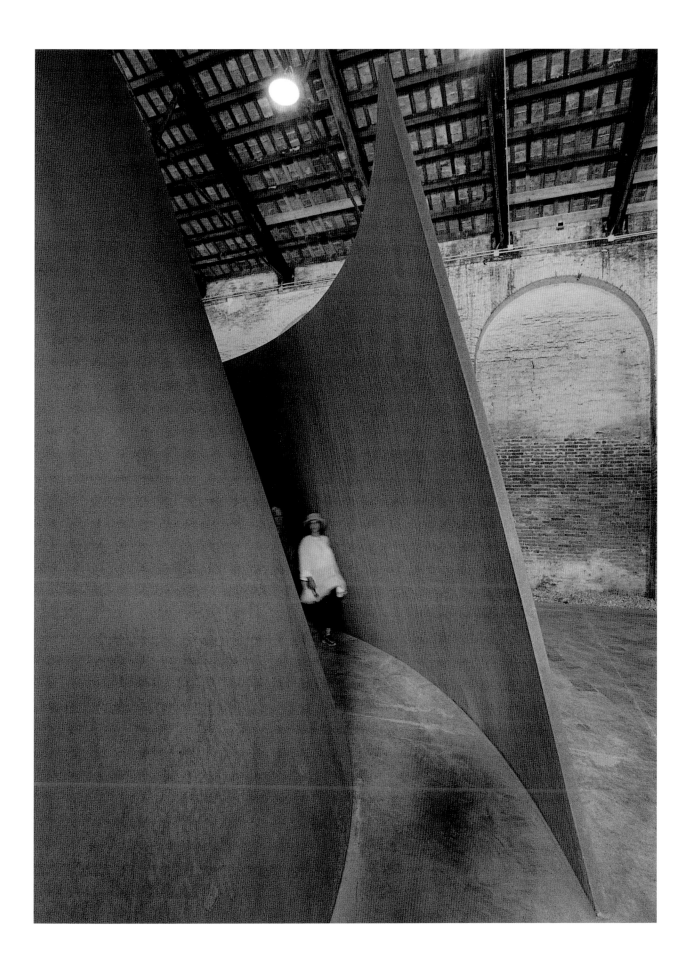

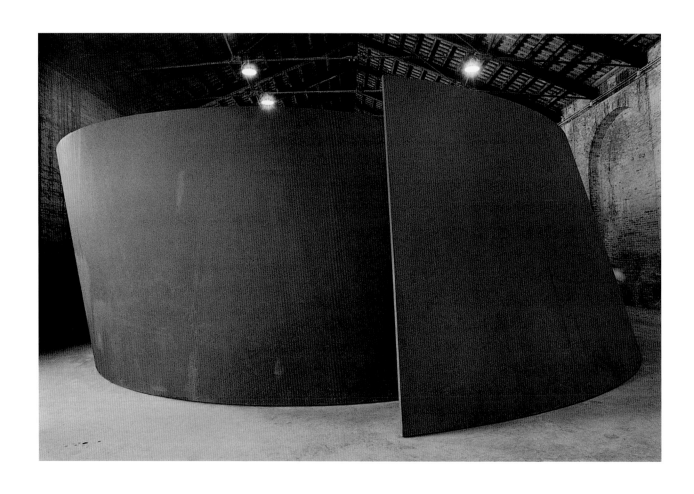

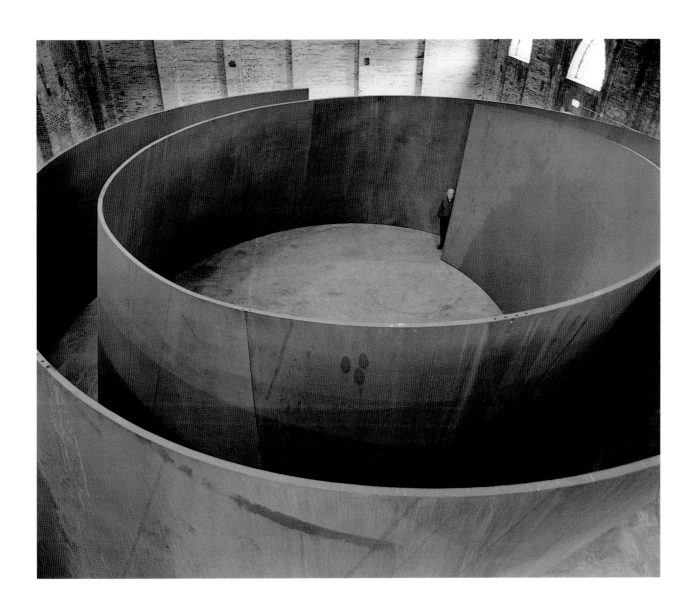

Betwixt the Torus and the Sphere

Three spherical sections;
Three torus sections, 2001

Weatherproof steel
Each approx.:11'10" x 37'6"
Overall: 11'10" x 37'6" x 26'7"
Plate thickness: 2"

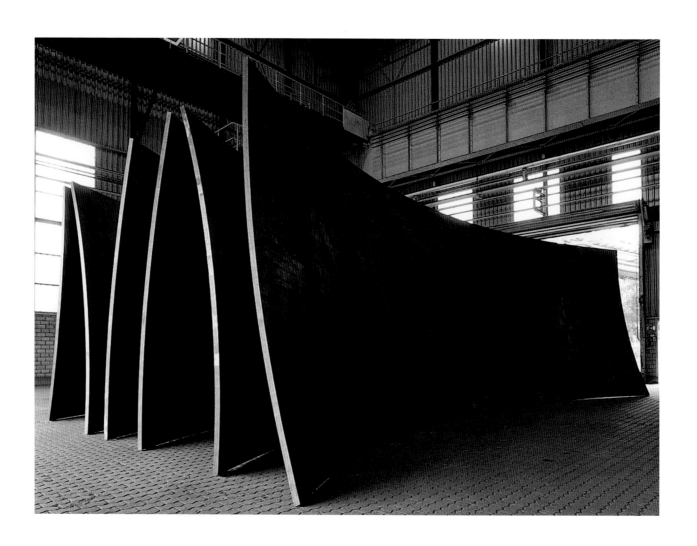

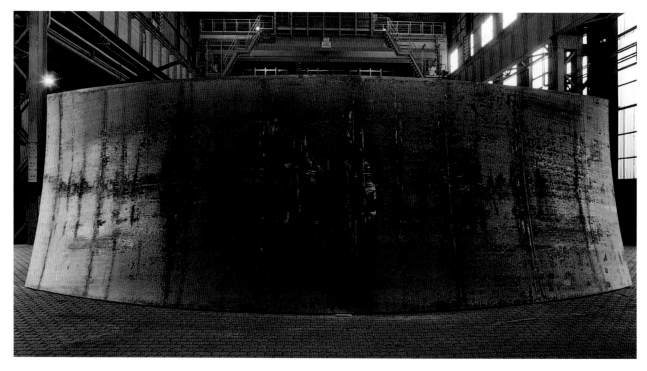

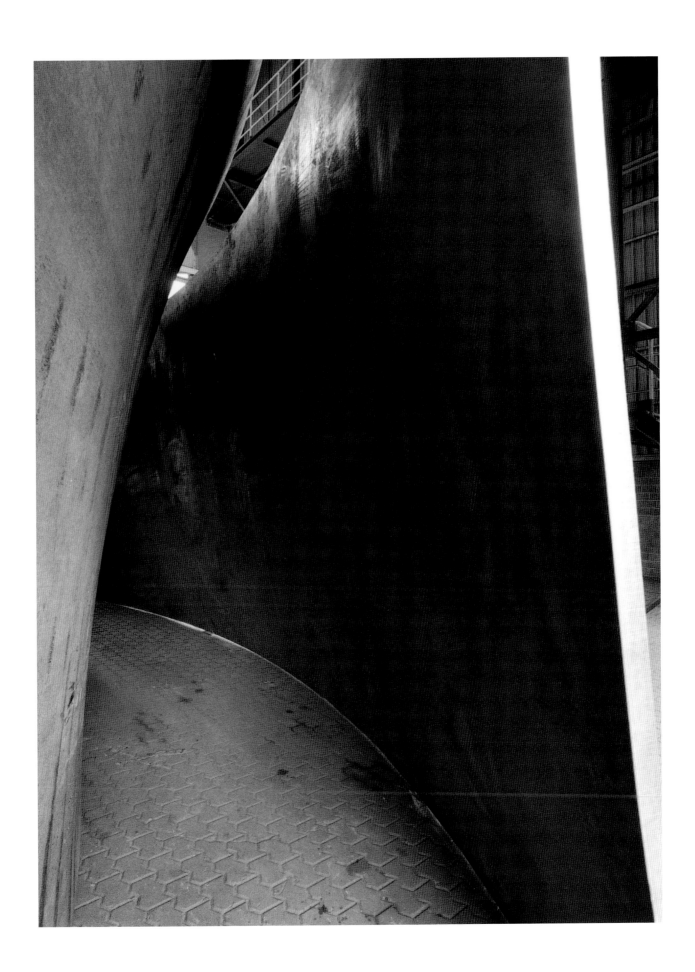

Union of the Torus
and the Sphere

One spherical section;
One torus section, 2001

Weatherproof steel

Spherical section: 11'10" x 37'9"

Torus section: 11'10" x 37'6"

Overall: 11'10" x 37'9" x 10'5"

Plate thickness: 2"

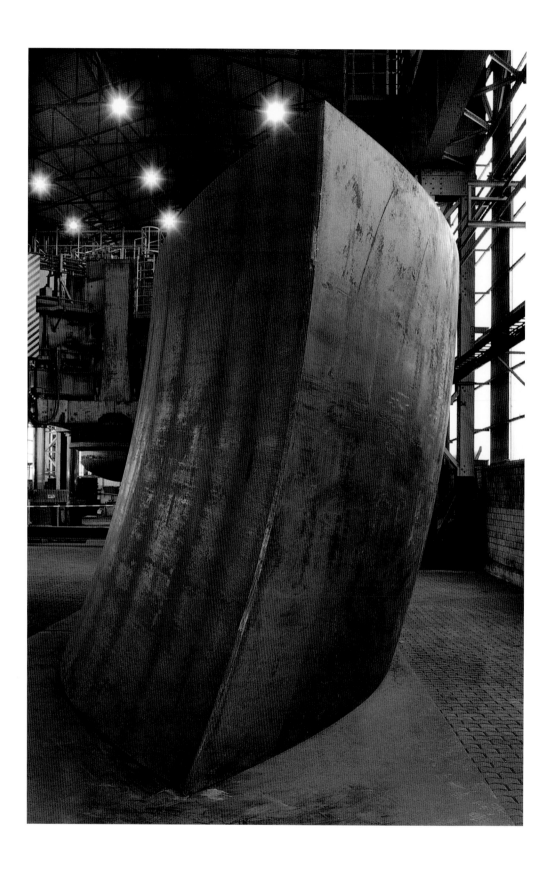

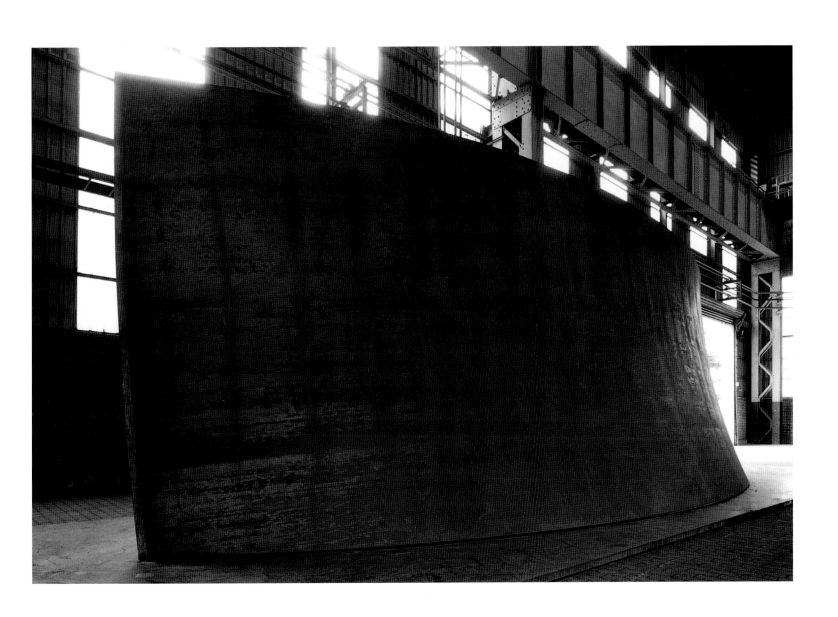

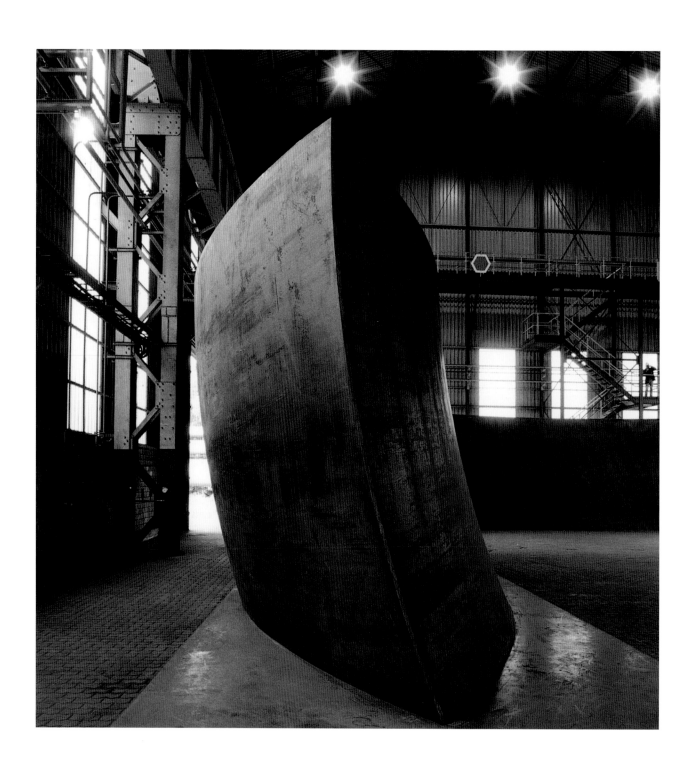

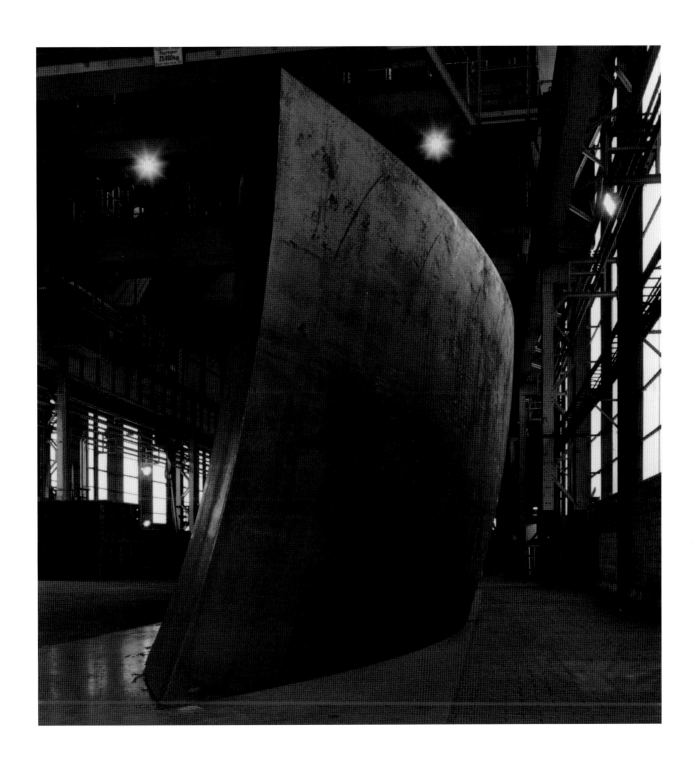

Checklist of the Exhibition

Ali–Frazier, 2001
Weatherproof steel
Two forged blocks placed
in separate identical rooms
3'5" x 5'8" x 9'1/2"
3'5" x 5' x 9'1/2"

Bellamy, 2001
Torqued spiral
Weatherproof steel
Overall: 13'2" x 44'3" x 32'10"
Plate thickness: 2"

Betwixt the Torus and the Sphere, 2001
Weatherproof steel
Three spherical sections
Three torus sections
Each approximately: 11'10" x 37'6"
Overall: 11'10" x 37'6" x 26'7"
Plate thickness: 2"

Elevational Wedge, 2001
Hot rolled steel
5" x 10'10" x 21'7 7/8"

Sylvester, 2001
Torqued spiral
Weatherproof steel
Overall: 13'7" x 41' x 31'8"
Plate thickness: 2"

Union of the Torus and the Sphere, 2001
Weatherproof steel
One spherical section: 11'10" x 37'9"
One torus section: 11'10" x 37'6"
Overall: 11'10" x 37'9" x 10'5"
Plate thickness: 2"

This catalogue has been published on
the occasion of the exhibition

Richard Serra
Torqued Spirals, Toruses and Spheres

October–December 2001

Gagosian Gallery
555 West 24th Street
New York, NY 10011
telephone 212.741.1111
www.gagosian.com

Design: Anthony McCall Associates, New York

Copy editor: Donald Kennison
Printing: Steidl, Göttingen

Gagosian Gallery Coordinators:
Lisa Kim, Melissa Lazarov, Jennifer Loh,
Courtney Plummer and Ealan Wingate

Gagosian Gallery would like to thank James Cullinane,
Ernst Fuchs, Allen Glatter, Trina McKeever and
Clara Weyergraf-Serra for their support and assistance
in realizing this exhibition and catalogue.

All photography by Dirk Reinartz unless otherwise noted.
Photograph on page 51 by WOWE, 2001

COVER
Bellamy

PAGE 2
Betwixt the Torus and the Sphere

PAGE 6
top: Sylvester
middle: Four
bottom: Left/Right

BACKCOVER
Union of the Torus and the Sphere

ISBN# 1-880154-59-5 (Gagosian Gallery)
ISBN# 3-88243-633-6 (Steidl)

Printed in Germany